What's Inside?

What is Zentangle®?

Zentangle is meditation achieved through pattern-making. A Zentangle is a complicated looking drawing that is built one line at a time. Simple tangles, or patterns, are combined in an unplanned way that grows and changes in amazing directions. With your mind engaged in drawing, your body relaxes. Anxiety and stress move to the back burner. Often, new insights are uncovered along with a sense of confidence in your creative abilities.

Zentangle was created by artists Rick Roberts and Maria Thomas as a tool to be used by artists and non-artists alike. For information about the process, instructions, and lots of beautiful examples, be sure to visit their website at **www.zentangle.com.**

Totally Tangled

TOOLS

All you really need:

- **pencil**
 Any No. 2 pencil will do. Find one without an eraser so you won't be tempted to "fix" your art.
- **Pigma Micron 01 black pen**
 With pigmented, non-bleeding, archival ink, these 0.25mm pens are a dream to draw with.
- **Zentangle tiles**
 These 3.5" square tiles are made from fine Italian paper. Once you tangle on these, you'll never be happy with cardstock (or note-paper!) again. Watercolor paper can make a nice surface to tangle on too, but be sure to cut it down to a manageable and portable size.

Tip: When first learning Zentangle, stick to just these tools - keep it simple. The point is to focus your mind on the lines and patterns and not worry about what pen to use.

Skip over the next page until you have finished a whole bunch of tiles!

04

"Zentangle" and the red square are registered trademarks of Zentangle, Inc.

an original

☐ z e n t a n g l e™

z e n t a n g l e . c o m

Copyright © 2004 Zentangle, Inc. All Rights Reserved

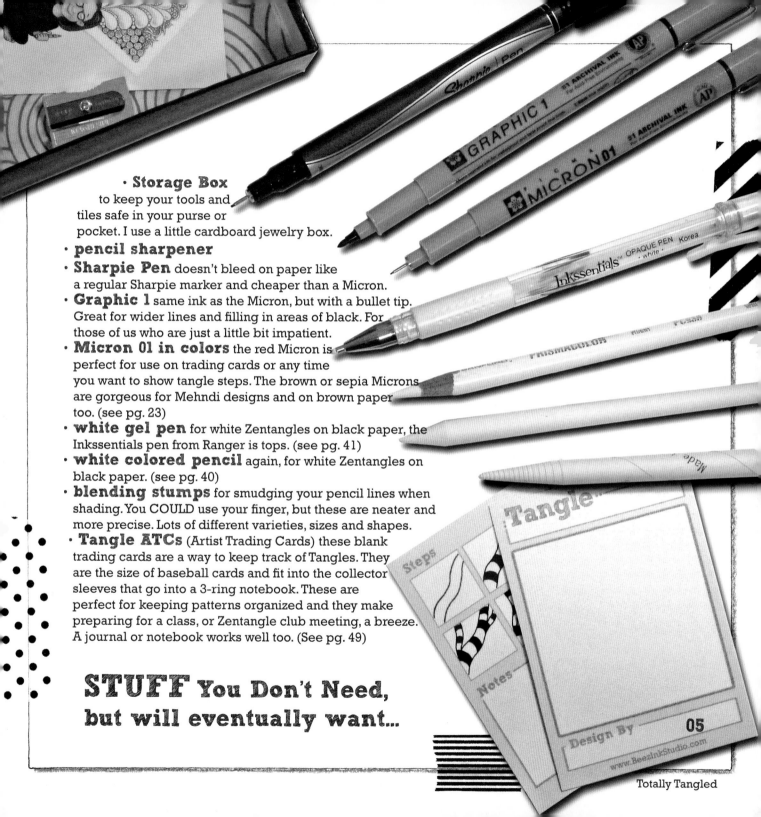

- **Storage Box** to keep your tools and tiles safe in your purse or pocket. I use a little cardboard jewelry box.
- **pencil sharpener**
- **Sharpie Pen** doesn't bleed on paper like a regular Sharpie marker and cheaper than a Micron.
- **Graphic 1** same ink as the Micron, but with a bullet tip. Great for wider lines and filling in areas of black. For those of us who are just a little bit impatient.
- **Micron 01 in colors** the red Micron is perfect for use on trading cards or any time you want to show tangle steps. The brown or sepia Microns are gorgeous for Mehndi designs and on brown paper too. (see pg. 23)
- **white gel pen** for white Zentangles on black paper, the Inkssentials pen from Ranger is tops. (see pg. 41)
- **white colored pencil** again, for white Zentangles on black paper. (see pg. 40)
- **blending stumps** for smudging your pencil lines when shading. You COULD use your finger, but these are neater and more precise. Lots of different varieties, sizes and shapes.
- **Tangle ATCs** (Artist Trading Cards) these blank trading cards are a way to keep track of Tangles. They are the size of baseball cards and fit into the collector sleeves that go into a 3-ring notebook. These are perfect for keeping patterns organized and they make preparing for a class, or Zentangle club meeting, a breeze. A journal or notebook works well too. (See pg. 49)

STUFF You Don't Need, but will eventually want...

The Basic Steps

1. Dots
2. String
3. Tangles
4. Shade
5. Initials

1. Dots- Using your pencil, make a dot in each corner of the tile. Connect the dots to form a border.

2. String- Draw the *String*.

3. Tangles- Switch to your pen and fill each section with *Tangles*.

"STRING" - a guideline, drawn in pencil (see pg. 08)

Knights-bridge (Z)
a checkerboard

Pearlz
(pg. 09)

Keeko (Z)
Draw this:)))) then draw this: ≋

Tip: Be sure to turn your tile as you draw. There is no right-side-up in Zentangle. Allow yourself to be surprised by what appears.

Talk like a CZT*:

"Zentangle" is a noun. Don't say: "I Zentangled my bathroom floor." Say: "I **tangled** my bathroom floor!" (I did! See pg. 44) Other things to say: "I need to **create** a Zentangle, right now!" "Sorry, I didn't hear you. I was busy **tangling**."

More Lingo:

"TANGLE" - a pattern taken from fashion, art, nature, observation, history... anywhere!

"ZENTANGLE" - the method of using pattern drawing to focus the mind. Also, the finished artwork.

* **"CZT"**- a Certified Zentangle Teacher who has been intensely trained by Rick Roberts and Maria Thomas, the Zentangle gurus and creators.

PIGMA MICRON 01 #1 ARCHIVAL INK AP

4. Shading- Use your pencil to add shading and depth. (See pg. 09)

5. Initial- As the final step, put your initials on the front of the tile, and sign and date the back. (There is no top or bottom to a Zentangle, so the initials can go anywhere).

Tip: It's fine if you prefer not to shade your Zentangles. Most of the tangles look great either way. However, I encourage everyone to TRY it. Shading gives the work a sense of depth and polish. Like magic, it can turn a simple, flat circle, into a a round, shiny bead! (See pg. 09)

Note: Each Tangle name is followed by initials in parentheses which represent the artist who created the tangle, or who worked out its steps. Page 50 has the complete list of artists.

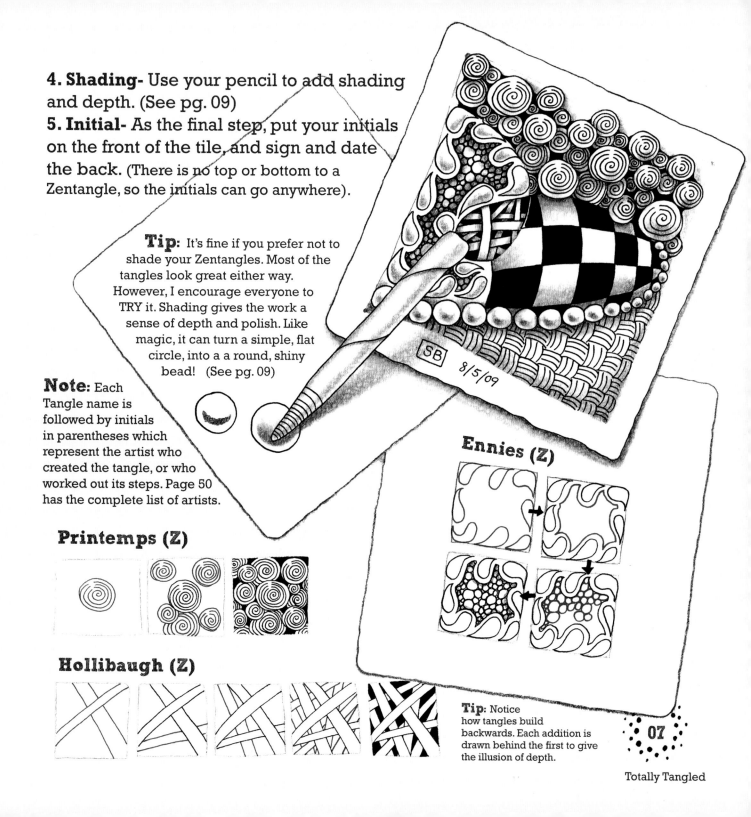

SB 8/5/09

Ennies (Z)

Printemps (Z)

Hollibaugh (Z)

Tip: Notice how tangles build backwards. Each addition is drawn behind the first to give the illusion of depth.

More about STRINGS

Strings are just guidelines, in pencil, put down to break up the terrifying "blank page" and to help organize your tangles. Imagine a piece of thread randomly dropped on your tile. Random swirlies and loops make great strings. Try using a Z shape or an X, or other letters. Circles, squares, triangles are all great. As you progress, your strings will get more complicated, like double swirlies, or trees, shells or fish. See pg. 40 for even more string ideas.

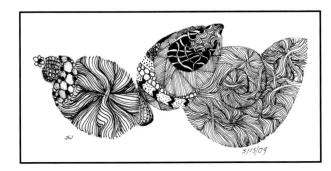

Tip: Circles, mandalas, or zendalas are an easy, relaxing way to create an orderly Zentangle.

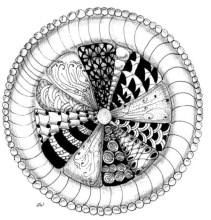

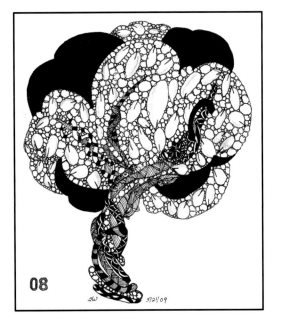

08

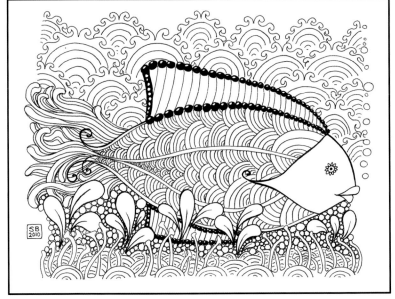

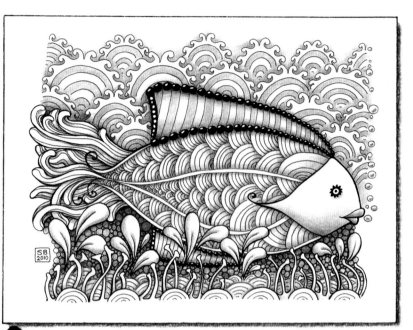

Why SHADE? Shading adds so much to a Zentangle. Compare this fish to the one on the opposite page. Shading can make objects "pop" from the page, hide errors (pen slips, smears. etc.) and tone down an overly busy background. Here are four basic uses and techniques for shading: Color, contrast, depth and roundness.

Color- the simplest shading just adds a third color to the basic black and white. Try gray in spots you normally use a solid black or white. It will add interest to dots, checks, stripes...

Contrast- a light object against a dark backround will be highlighted and pop forward. Dark against light will recede, or look like a hole in the surface. Using gray shading, adds a middle ground. Here, it makes the busy bubbles recede and the plants pop up.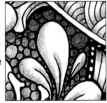

Depth- to make something look like it is going under another object, add a little shadow on either side of the top object.

lines only shading below blended

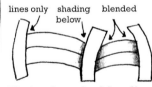

Notice how the blending gradation actually makes the pattern looked curved?

See *Pane* on page 39 for an example of shading for depth.

Roundness- a crescent of shading, or a white highlight.

Pearlz (SB)

blending in a circle creates a darker pearl shading between makes it seem the pearl is sitting on the paper

Beedz (SB)

draw a circle at the top for the highlight and fill in the rest of the bead with your pencil or pen. The contrast makes the highlight appear closer and rounder.

Beedle (SB)

09

Crossroads (SS)

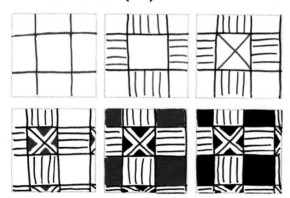

Flutter Tile (SB)

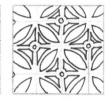

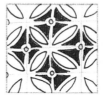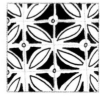

See the Tangle Index for lots of variations on the *Flutter* tangle.

Matt (PS)

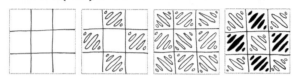

Ballot (SB)

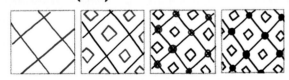

Kaleido (SB)

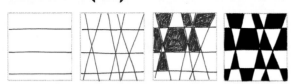

GRIDS

are the basic building blocks of many patterns. Some are obvious like a checkerboard (*Knightsbridge p.06*). Others, like *Chic* (p.11), completely conceal the grid they were built upon.

The magic of grids is that just changing the size of the squares, or skewing the lines, can give the illusion of depth - even without added shading.

Chic (SB)

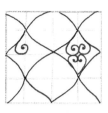 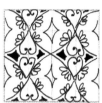 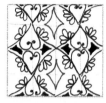

 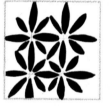 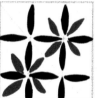

Pollen (SB)

Hemp (SB)

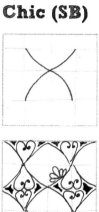

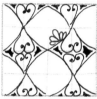

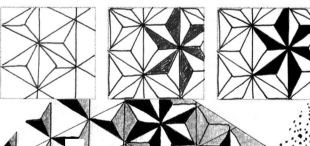

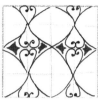

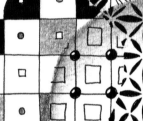

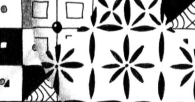

Tip:
Look for sections that are "reflected." This can indicate where the grid lines would be. Do you see how *Chic* and *Flutter Tile* are reflected or mirrored over each grid line?

11

Adele (SB)

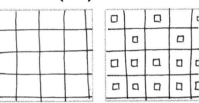

Kuginuki (SB)

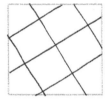 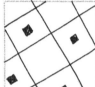 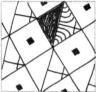

Stubert (SB)

 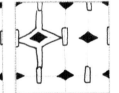

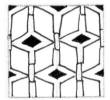 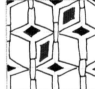 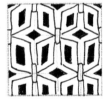

Tip: Warping your grid (curving the lines) creates easy 3-D effects.

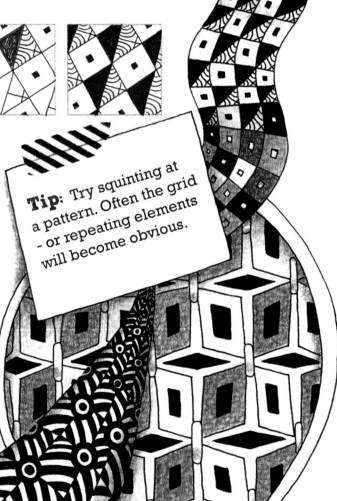

Tip: Try squinting at a pattern. Often the grid - or repeating elements will become obvious.

Popova (SB)

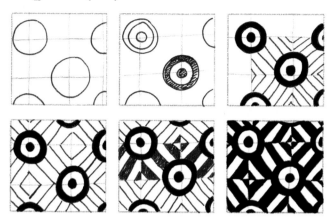

Puff-O (SB)

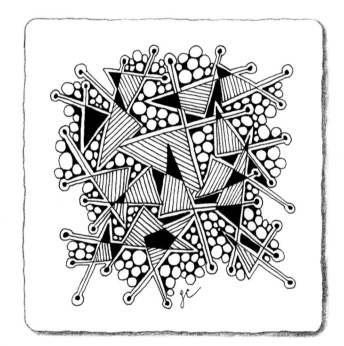

Triangle (LC)

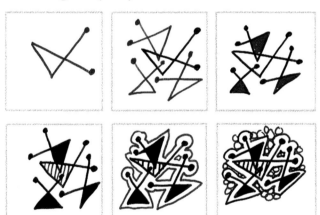

Tip: Circles can be used on grids too. And triangles are fun both random and orderly.

Herald (SB)

 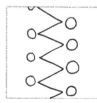

13

Totally Tangled

Omega (SB)

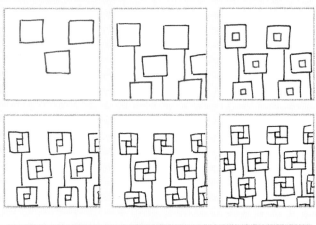

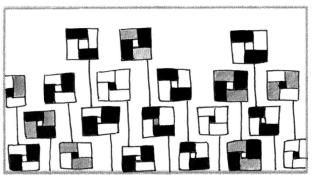

Fetti (SB)

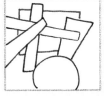

Modern Art

It may seem rather obvious, but art is full of patterns! Take a careful look through an art history book.

Gyro (SB)

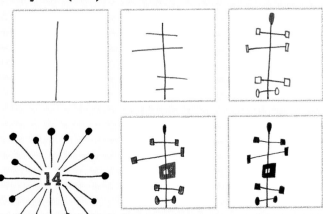

Totally Tangled

Look into the details - the carpets, walls, mosaics, backgrounds. There are fantastic patterns lurking in almost every painting. And don't forget to examine posters, fabric, pottery, hotel art, lamps, graffitti, ironwork...

Emilie (SB)

Lampen (SB)

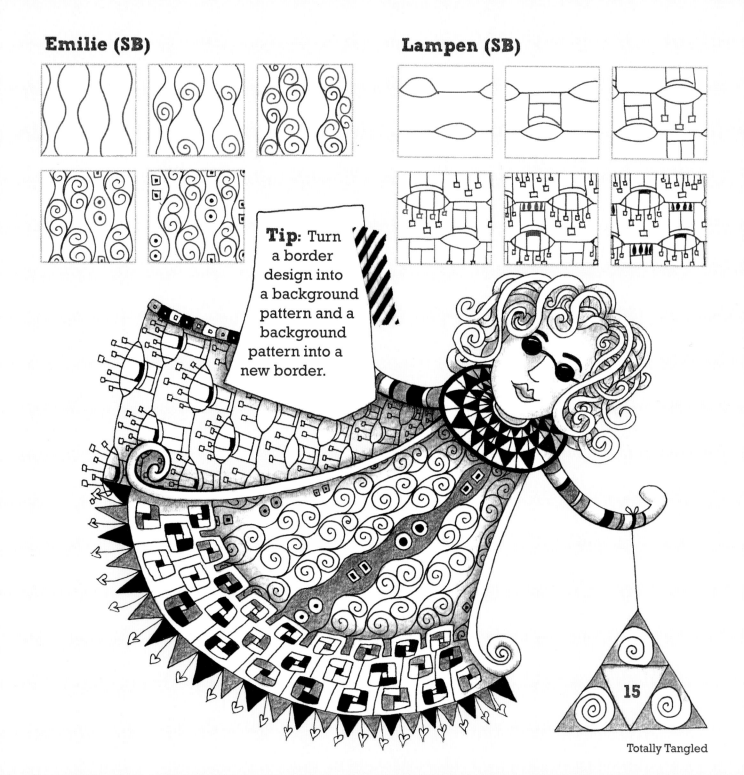

Tip: Turn a border design into a background pattern and a background pattern into a new border.

15

Totally Tangled

Alps (SB)

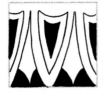

See page 22 for *Alps* used in a Mehndi border.

See page 22 for *Alps* used in a Mehndi border.

Combine 'em! Each of these tangles has many variations. But what if you put them all together? *Bauer* is a combination of *Alps*, *Buttercup*, *Flutter* and *Flora*. And if one looks nice, how about a whole background pattern created from *Bauer*? That's right - just build it on a grid.

Buttercup (SB)

 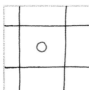 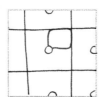 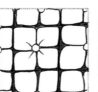 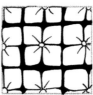

Tip: The image on page 17, bottom right, is completely formed from these five tangles. Notice how the circle of petals is formed from *Alps*.

Flutter (SB)

 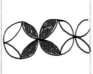 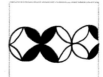

FlutterBi (SB)

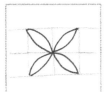 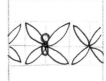

16

Totally Tangled

Flora (SB)

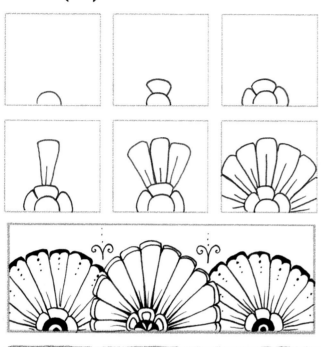

Bauer (SB)

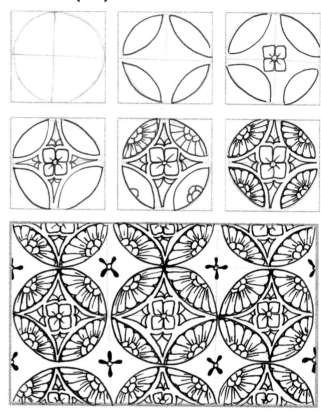

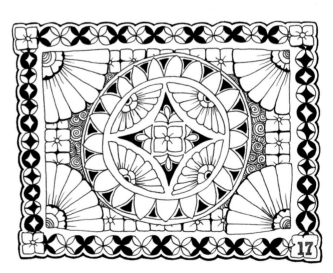

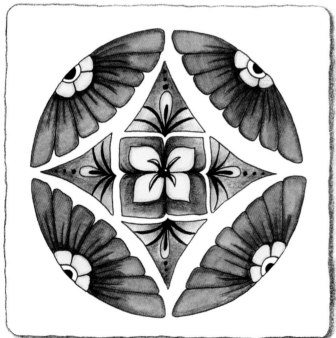

Claire (SB)

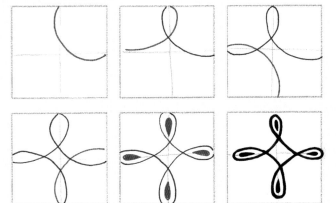

Miranda (SB)

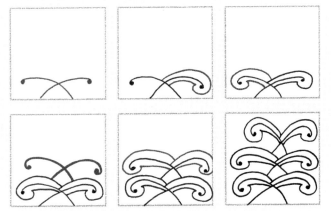

Xing (BA)

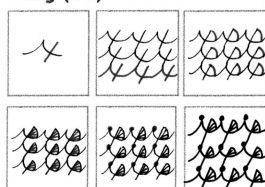

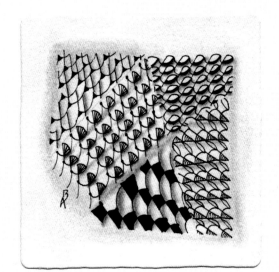

Tip: Can you use your own hand-writing to form a tangle?

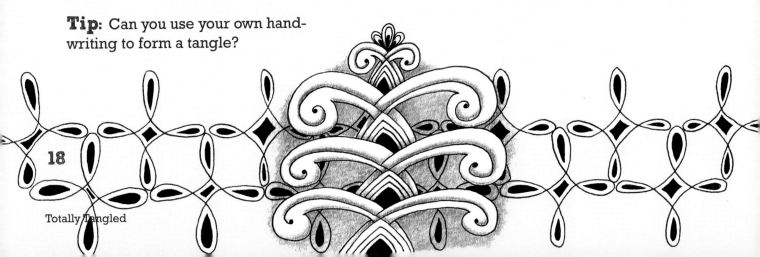

18

DotnDash (MASD)

Lacy (SS)

Chemystery (MASD)

Weave (KAY)

Molecule (ST)

Punch (SB)

Tip: The order in which the steps are drawn can change the look of a tangle. Look carefully at *Chemystery* and *Molecule*. Their steps are reversed.

Tip: Use any large, bold pattern or shape beneath *Punch*... flowers, hearts, stars... And remember to add the little arc of shadow for depth.

Jacki (SB)

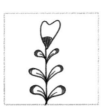

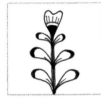

Laydee (SB)

It should come as no surprise that many of the traditional Zentangle patterns come from cultures all over the world.

With these designs from **India**, try mixing up the different flowers and stems. Using an **aura** (or outline) around the more delicate areas will make them stand out from the background.

Tip: Despite the chaotic, organic look of these plants, notice how orderly the sections of leaves and petals are.

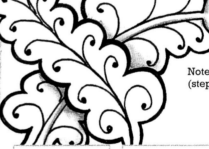

Note the auras for *Laydee* (step 3) and *Chugh* (step 5).

Chugh (SB)

20

Totally Tangled

Bollywood (SB)

Whiska (SB)

Mehndi designs, or the henna tattoos worn by women in India, are some of my personal favorites for tangling. These designs are created by squeezing paste onto skin - one stroke at a time. Just like Zentangles, they appear elaborate and intimidating. But when broken down, step by step, they are really quite simple.

Bic (SB)

Queste (SB)

Flutterbud (SB)

22

Totally Tangled

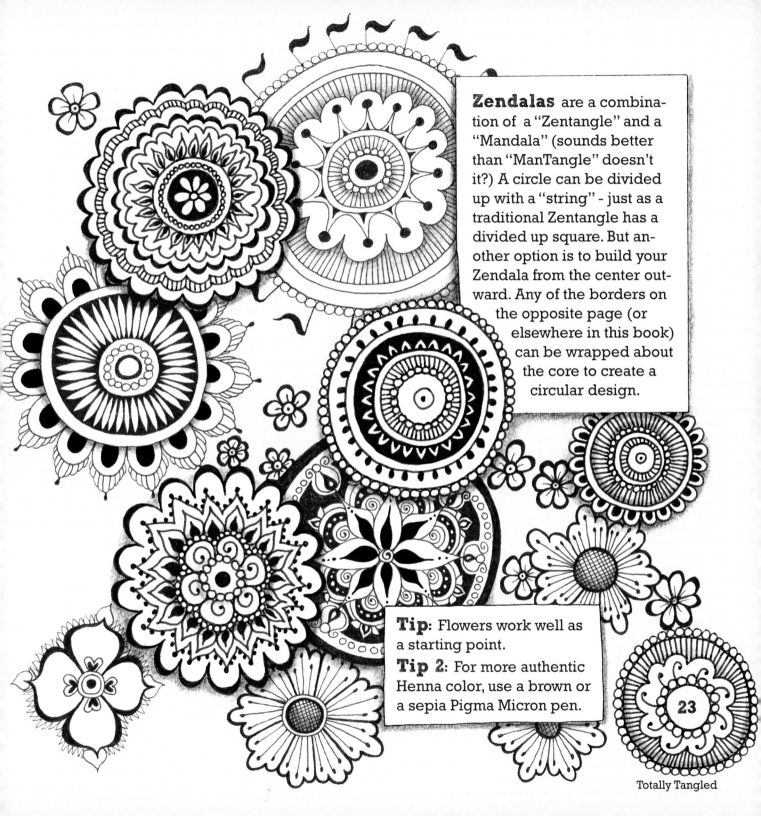

Zendalas are a combination of a "Zentangle" and a "Mandala" (sounds better than "ManTangle" doesn't it?) A circle can be divided up with a "string" - just as a traditional Zentangle has a divided up square. But another option is to build your Zendala from the center outward. Any of the borders on the opposite page (or elsewhere in this book) can be wrapped about the core to create a circular design.

Tip: Flowers work well as a starting point.
Tip 2: For more authentic Henna color, use a brown or a sepia Pigma Micron pen.

23

Marquee (SB)

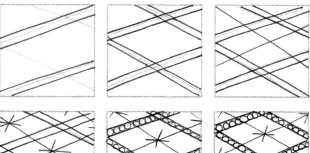

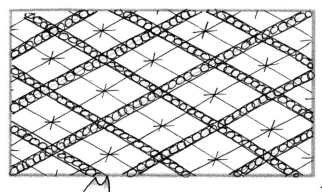

Steem (SB)

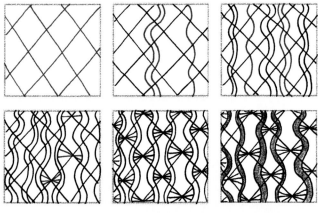

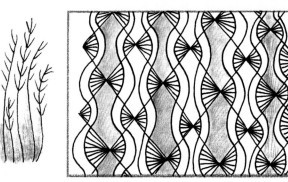

Japanese kimonos are a rich source of patterns. The two tangles above are both based on diagonal grids where the lines are part of the design. Notice how the grid in *Treasure* (pg. 25) is disguised by black and seems to become a diagonal grid.

Sproing (SB)

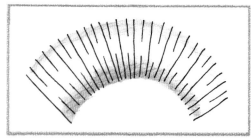

24

Treasure (SB)

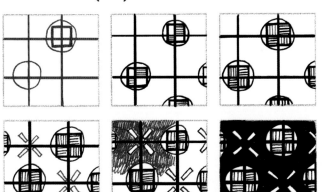

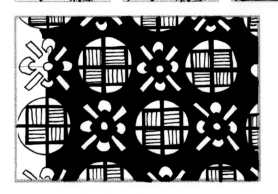

Unagi (SB)

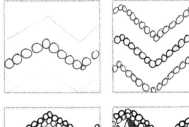

If you eat
sushi then you
know "Unagi"
means "eel."

25

Totally Tangled

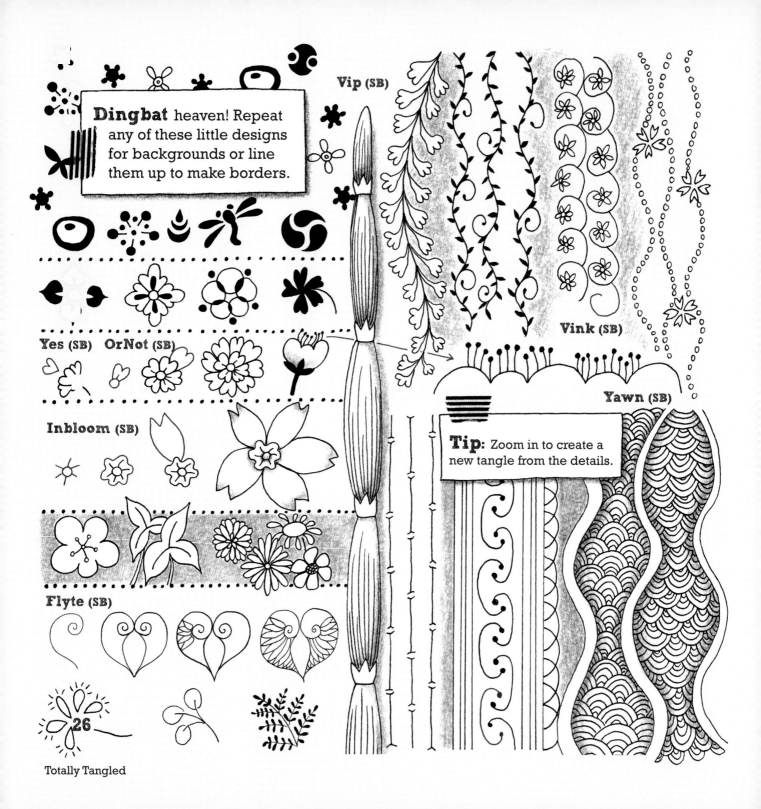

Dingbat heaven! Repeat any of these little designs for backgrounds or line them up to make borders.

Vip (SB)

Vink (SB)

Yes (SB) OrNot (SB)

Yawn (SB)

Tip: Zoom in to create a new tangle from the details.

Inbloom (SB)

Flyte (SB)

26

Totally Tangled

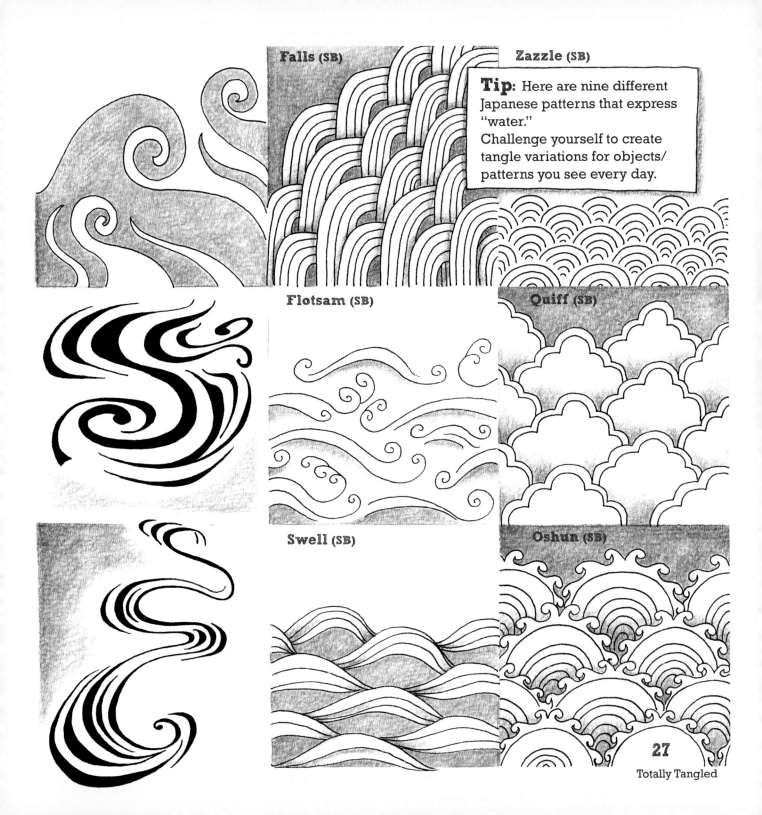

Falls (SB)

Zazzle (SB)

Tip: Here are nine different Japanese patterns that express "water."
Challenge yourself to create tangle variations for objects/ patterns you see every day.

Flotsam (SB)

Quiff (SB)

Swell (SB)

Oshun (SB)

Swaddle (SB)

Why this name?
This tangle is
based on mummy wrappings
- extremely simplified!

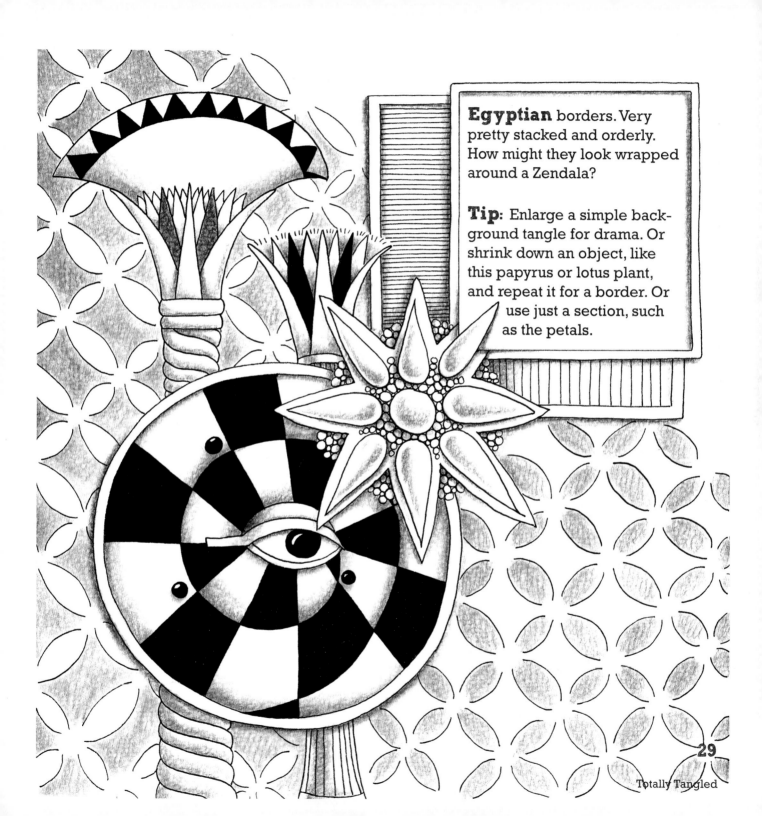

Egyptian borders. Very pretty stacked and orderly. How might they look wrapped around a Zendala?

Tip: Enlarge a simple background tangle for drama. Or shrink down an object, like this papyrus or lotus plant, and repeat it for a border. Or use just a section, such as the petals.

Gust (SB)

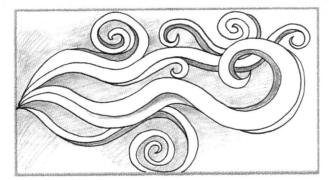

Ripple (SB)

 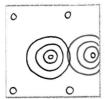 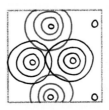

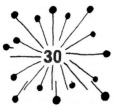

Totally Tangled

Fyre (SB)

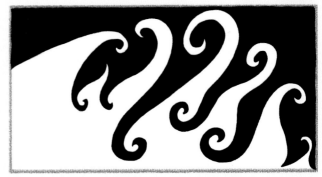

CUdad (SB) "ciudad" is Spanish for "city"

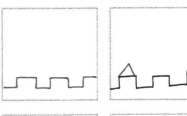 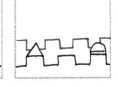

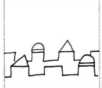 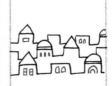

Flaske (SB)

 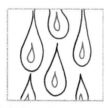

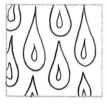 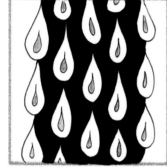

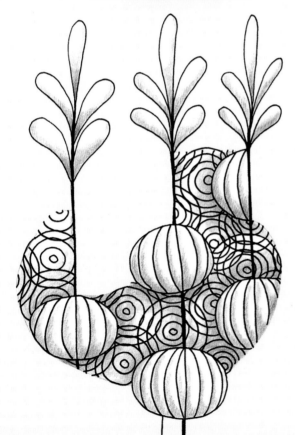

Punkin (SB)

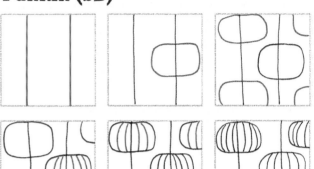

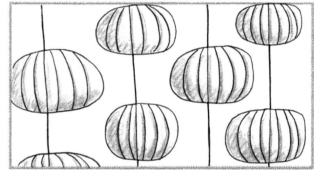

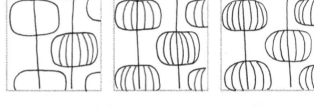

Nebel (SB)

 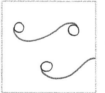 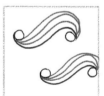

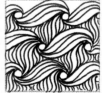 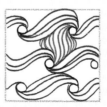

Totally Tangled

Buoy (SS)

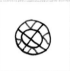 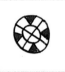 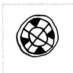

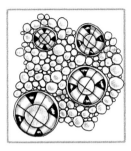

Holey (KAY)

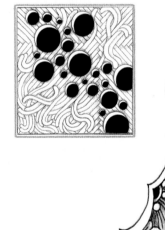

Tip:
What's inside Holey? Look at page 35 for ideas!

Tip: Notice how *Holey* and *Boing* both have the same elements: a black circle and a white highlight. Why does *Holey* create a... hole, and yet *Boing* springs off the page?

Boing (SB)

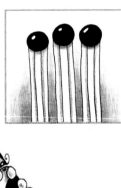

32

Awdry (SB)

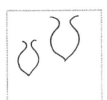 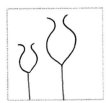

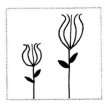 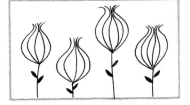

Pods (SB)

 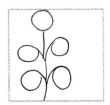

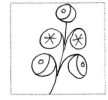 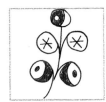 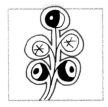

Bambu (SB)

See page 26 (center-bottom) for another, more simplified way to draw Bamboo.

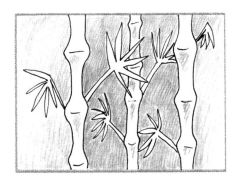

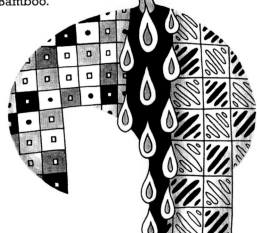

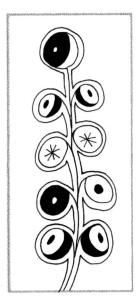

Kogin (MSP)

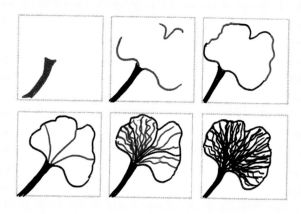

Xpetal (SS)

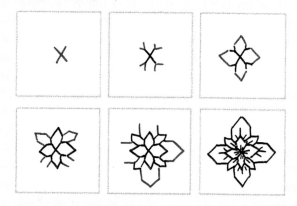

Why that name?

Melissa rearranged "Gingko" to create a new name..."Kogin."

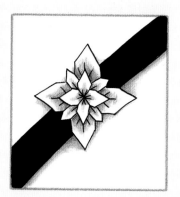

Totally Tangled

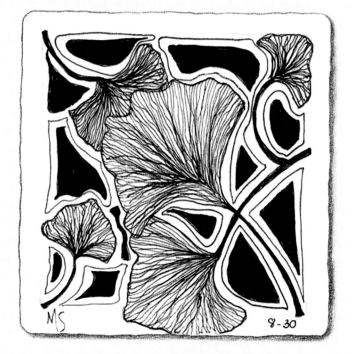

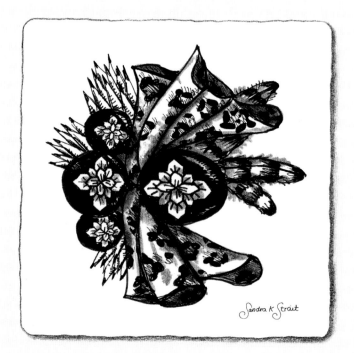

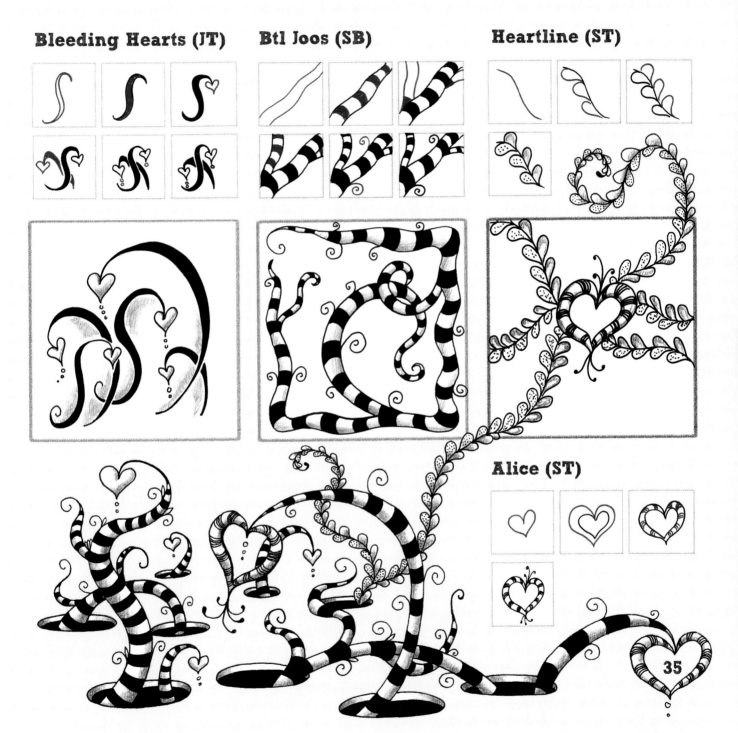

Bleeding Hearts (JT)

Btl Joos (SB)

Heartline (ST)

Alice (ST)

35

Totally Tangled

Leopard (SS)

Nature is an inspiration for Sandra Strait. She created these four tangles by zooming in to find shapes and textures.

Urchin (SS)

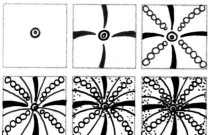

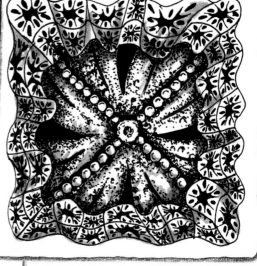

Jay (SS)

Lacy (pg. 19) creates a flowing border for *Urchin* that reminds me of waves.

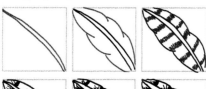

Remember:
Don't let yourself be limited by the names of the tangles.

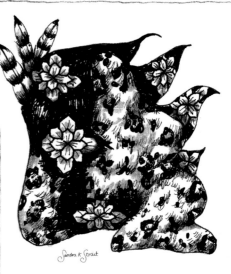

Caterpillar (SS)

What else might *Caterpillar* be? (See pg. 47 and the back cover)

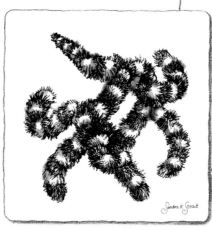

Hairy (KAY)

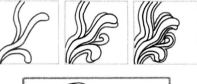

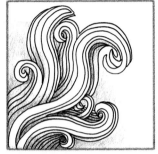

Muzic (CP)

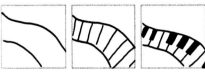

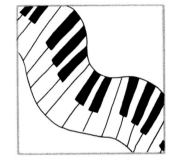

Stubs (SS)

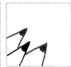

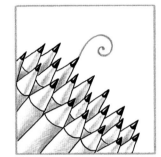

Linky (SB)

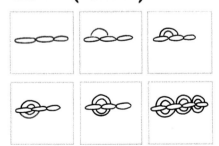

Linkd (MASD)

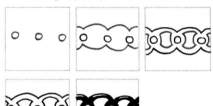

ButNZ (MASD)

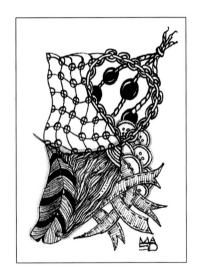

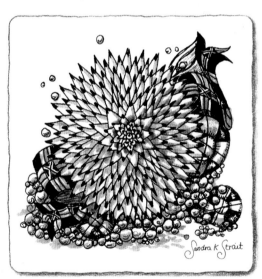

Look at the **Ordinary Things** around you. Hair, a keyboard, pencils, buttons, beads, stitching - have you ever seen them as patterns instead of objects?

Imagine *Stubs* becoming a magnificent sea creature! Talk about turning the ordinary into the extra-ordinary!

Bannah (SB)

Abacus (SB)

Tip: Look at page 09 for ideas on shading white and black beads.

Ramy (SB)

Scraper (SB)

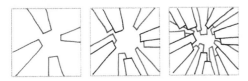

Newell (SB)

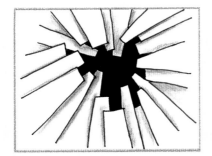

Pane (SB)

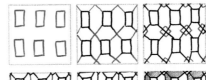

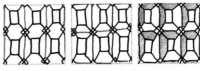

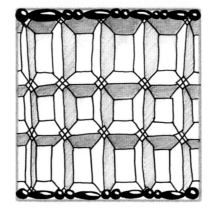

HiRise (SS)

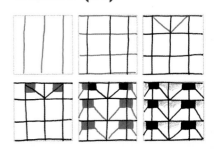

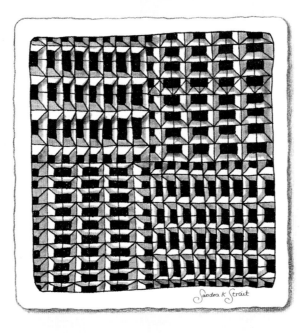

Sandra K Strait

Why that name?
Scraper was inspired by **Architecture** - looking up at skyscrapers, but also could look like a hole punched through something. *Pane* is from a beveled glass window, but might also be wood paneling. And *Beedle* was found edging a wooden fireplace.

39

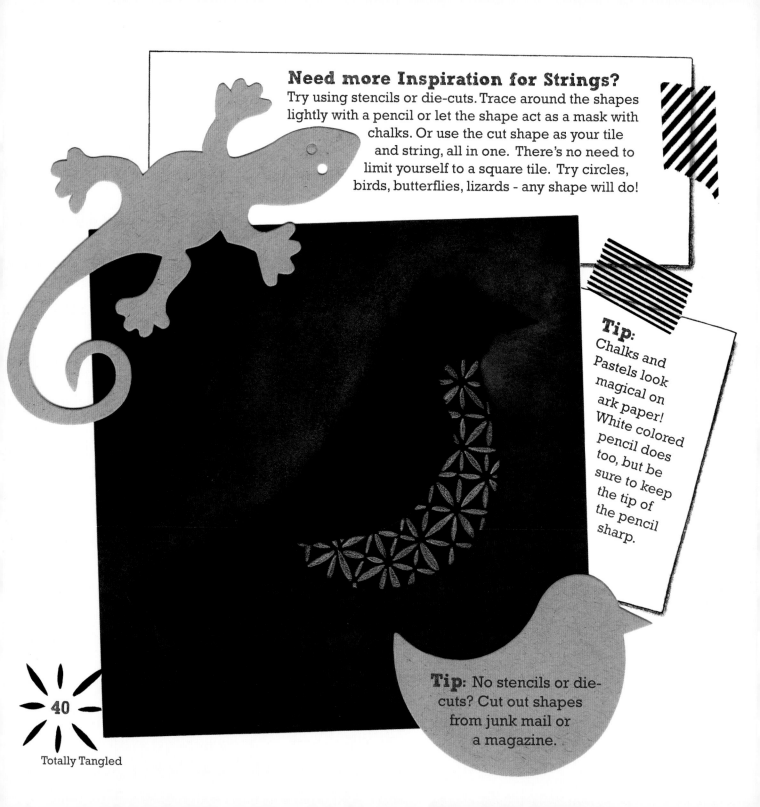

Need more Inspiration for Strings?

Try using stencils or die-cuts. Trace around the shapes lightly with a pencil or let the shape act as a mask with chalks. Or use the cut shape as your tile and string, all in one. There's no need to limit yourself to a square tile. Try circles, birds, butterflies, lizards - any shape will do!

Tip: Chalks and Pastels look magical on ark paper! White colored pencil does too, but be sure to keep the tip of the pencil sharp.

Tip: No stencils or die-cuts? Cut out shapes from junk mail or a magazine.

40

Totally Tangled

White on Black makes for very striking Zentangles. This Mehndi inspired hand was first traced lightly with white colored pencil onto the black circle tile. It was then filled in using a white gel pen. The white pencil can also be used to do subtle shading (or highlights) on the black paper.

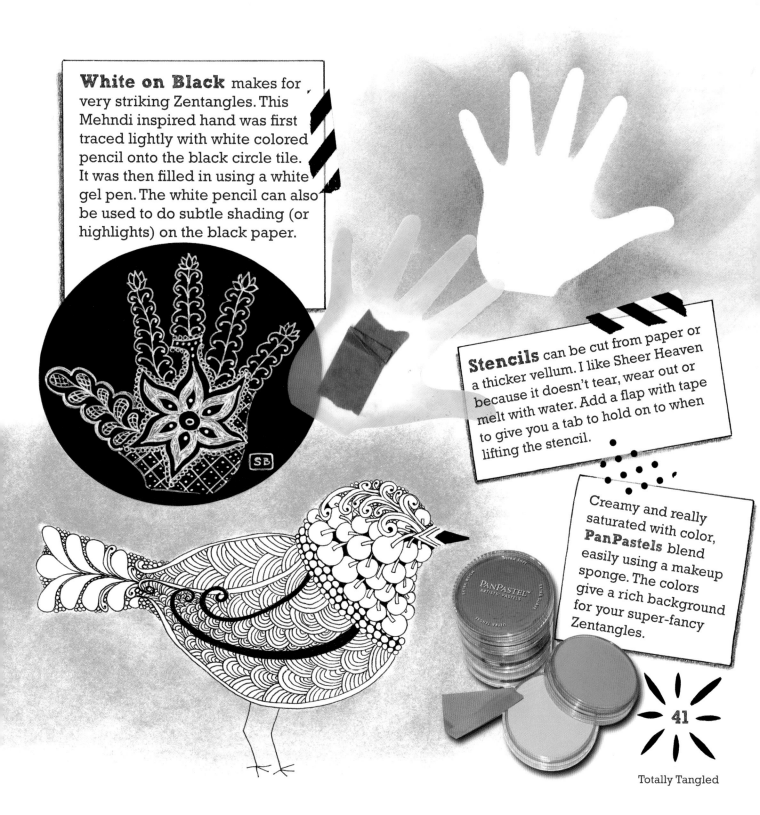

Stencils can be cut from paper or a thicker vellum. I like Sheer Heaven because it doesn't tear, wear out or melt with water. Add a flap with tape to give you a tab to hold on to when lifting the stencil.

Creamy and really saturated with color, **PanPastels** blend easily using a makeup sponge. The colors give a rich background for your super-fancy Zentangles.

41

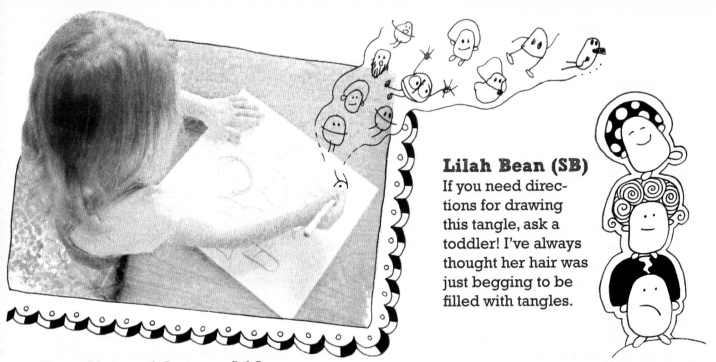

Lilah Bean (SB)

If you need directions for drawing this tangle, ask a toddler! I've always thought her hair was just begging to be filled with tangles.

Tangling with your kids

Kids are naturals at creating Zentangles. Just give them some markers and paper and help them notice patterns and shapes around them.

But they are also great inspiration for creating your own tangles. My daughter Lilah Amaret started drawing these little "jelly-bean people" when she was two years old. I "borrowed" the lady below.

Tip: For more ways to use kids' drawings in your tangles, look at the word "child" in my drawing on the opposite page. Use what you've learned about shading and contrast to add sophistication to your design.

Note: These two photos, and Lilah's drawings, are transfers in my journal made using Sheer Heaven paper. See "Resources" pg. 50 for info.

42

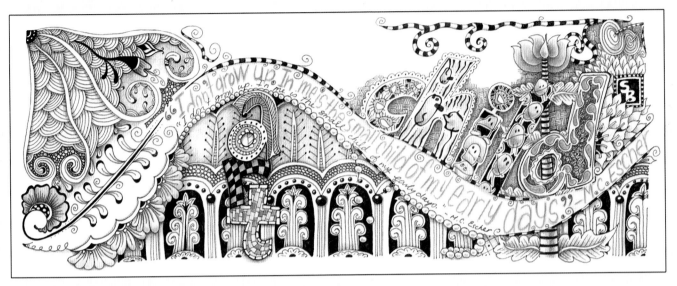

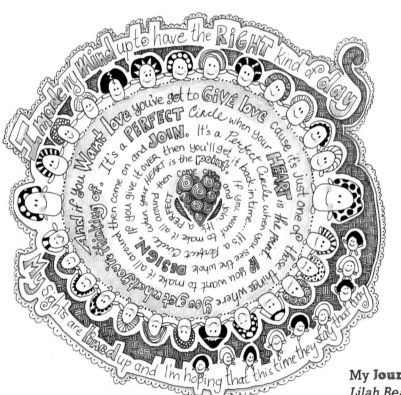

These words are song
lyrics from "Whole Design" by Sabrina Scott

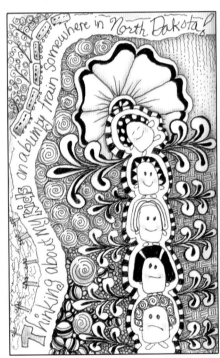

My **Journals** are where these little
Lilah Beans seem to show up most often!

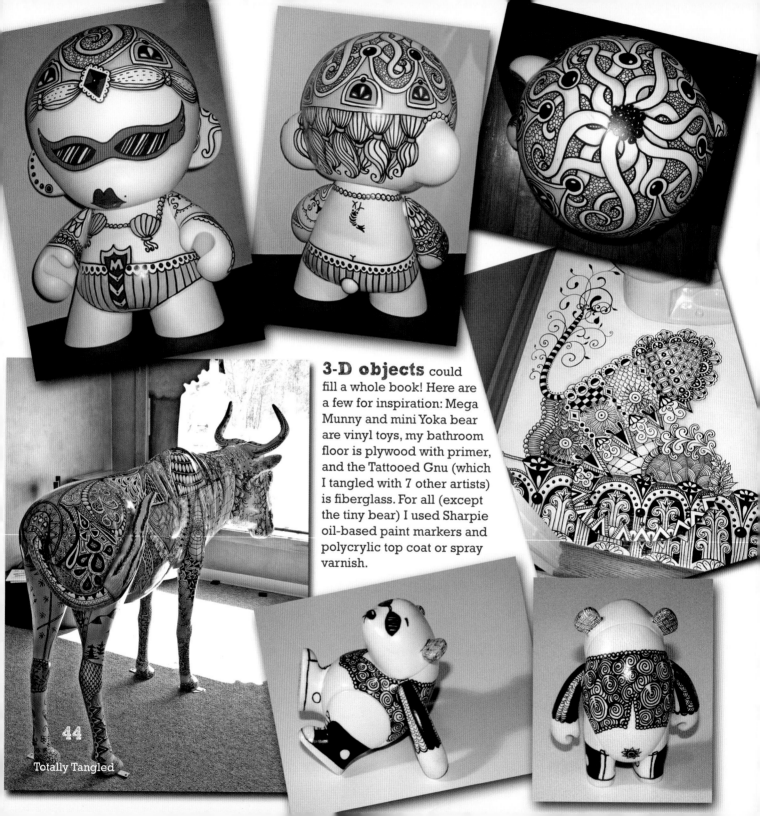

3-D objects could fill a whole book! Here are a few for inspiration: Mega Munny and mini Yoka bear are vinyl toys, my bathroom floor is plywood with primer, and the Tattooed Gnu (which I tangled with 7 other artists) is fiberglass. For all (except the tiny bear) I used Sharpie oil-based paint markers and polycrylic top coat or spray varnish.

Above: "Tangled Muse" - collage, acrylic paints
Below: "Flower Collage" - stampbord, glass mini-
tiles, rubber stamps, acrylic paints, Micron pen

Right: Zentangle

Left: Illustration

Color changes
everything!

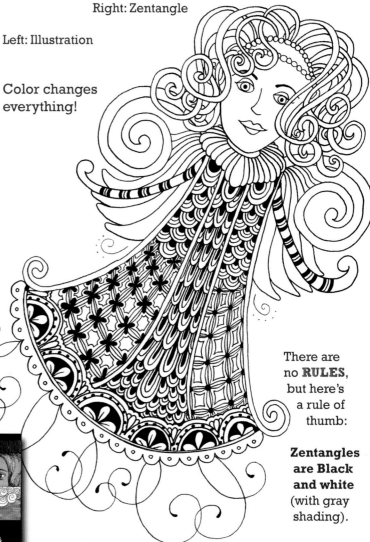

There are
no **RULES**,
but here's
a rule of
thumb:

**Zentangles
are Black
and white**
(with gray
shading).

The more **color** you add, the more
distracting it becomes. And then -
the more you have to THINK.
(Thinking is bad.)
That said, there's nothing wrong
with art being "Zentangle-ish" or
"inspired by Zentangle." It doesn't
always have to be traditional.

45

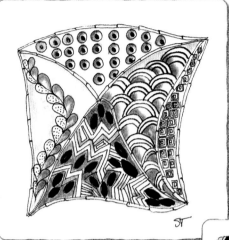

Tip: Shelley suggests framing your larger Zentangles on pieces of fabric or handmade papers.

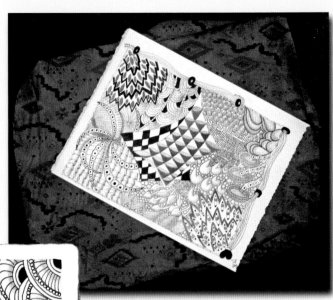

These Zentangles were done by SherRee and Shelley, two ladies who work at my store. Both self-described non-artists. I taught them the basics so they could explain to customers what we were doing to the Gnu (pg. 44). I was amazed at the time that

they both took to it so quickly. Shelley, who tangles daily, filled many Moleskine accordian journals with her designs. And SherRee's beautiful pieces are on blogs and FaceBook. (see more on pg. 08) They both now call themselves artists.

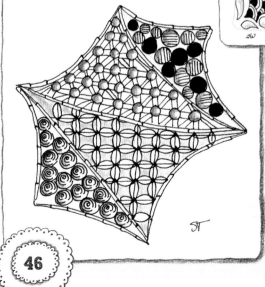

Tip: Save all your tiles! Sign and date the backs and put them in a box or notebook. Not only is it fascinating to review your progress over time, but as you continue, you will learn new techniques and skills that may "fix" what you think of as mistakes.

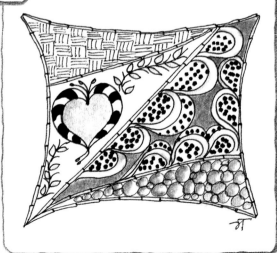

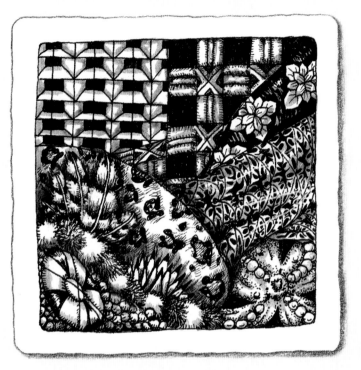

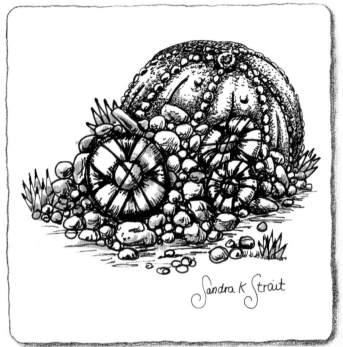

Sandra K Strait

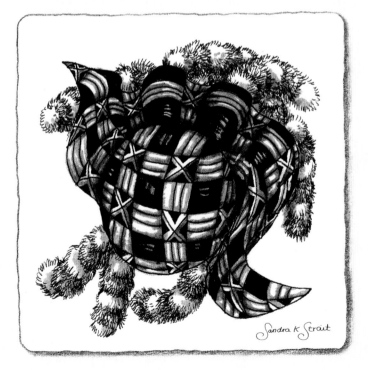

Sandra K Strait

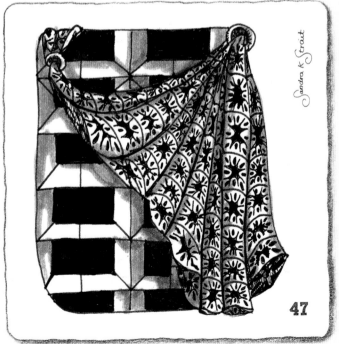

Sandra K Strait

47

Totally Tangled

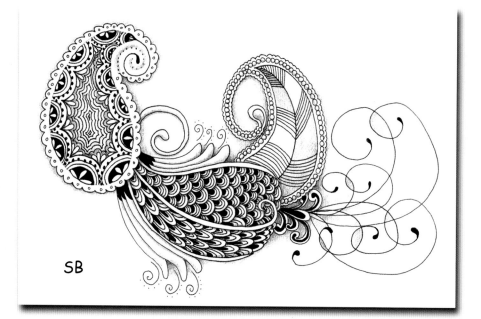

SB

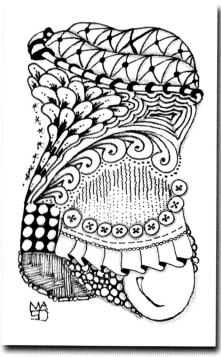

Tip: What skills do you already possess that you can combine with Zentangle? Math, books, writing, flower arranging, hiking, sewing… (Note the buttons and fabric in MaryAnn's tangles).

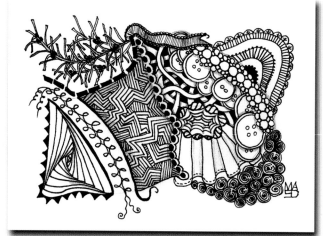

48

Totally Tangled

I had been tangling for a year and a half before it occurred to me to incorporate my illustration style into my Zentangles (top and right). Now, I like to add words and creatures whenever I can.

Art is Medicine

Journals, sketchbooks, idea books. Whatever you like to call it - you need one (or six - no kidding)! As soon as you start to practice Zentangle, you will start to see patterns and designs everywhere.

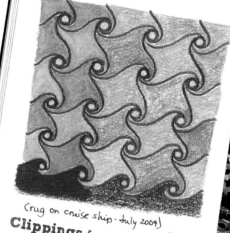

(rug on cruise ship - July 2009)

Clippings from magazines and catalogs give me great ideas. I rarely notice the clothes anymore - just the fabric designs.

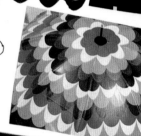

Zentangles of France

PARIS

CARCASSONNE

CARCASSONNE

RENNES-LE-CHATEAU

DURFORT

CARCASSONNE

MONTOLIEU

SAINT-FÉLIX

REVEL

Tip: When I travel, I bring my teeny Polaroid PoGo printer. The photos are little stickers!

Tip: My favorites are my Hand Book journal (top) which also comes in a square format, and my Moleskine sketchbook (left). Both have a convenient pocket in the back for storing stencils, clippings and ATCs.

49

ARTISTS

(BA) - **Bette Abdu**, CZT
New Hampton, NH
betteabdu@gmail.com
(CP) - **Casey Poirer** - NH
(JT) - **Jean Theurkauf**, CZT - Sterling MA
jean@threadgardens.com
(KAY) - **Karenann Young** - AZ
www.KarenAnnYoung.blogspot.com
karenannyoung@yahoo.com
(LC) - **Linda Cobb**, CZT
Tyler Hill, PA
fallsdalestudios@yahoo.com
(MASD) - **MaryAnn Scheblein-Dawson**, CZT
Franklin Square, NY
www.paperplay-origami.com
(MS) - **Melissa St. Pierre**
Warner, NH
(PS) - **Peggy Shafer** - NH
(SB) - **Sandy Bartholomew**, CZT
Warner, NH
www.beezinkstudio.com
(SS) - **Sandra K. Strait**
Fairview, OR
www.LifeImitatesDoodles.blogspot.com
(ST) - **Shelley Trube** - Warner, NH
Shelley@wingdoodle.com
(SW) - **SherRee Coffman West**
Warner, NH
Sherree@wingdoodle.com
(Z) - **Zentangle**
www.zentangle.com

RESOURCES

Ampersand Art, Stampbord tiles
www.stampbord.com

Beez in the Belfry, Sandy's blog
beezinthebelfry.blogspot.com

Bumblebat, Zentangle supplies, books
www.bumblebat.etsy.com

Design Originals, 'how-to' books
www.d-originals.com

Dick Blick, PanPastels, pens, journals.
www.dickblick.com

Happy Tape, Japanese masking tape
www.happytape.com

PanPastels, tutorial videos
www.panpastel.com

Polaroid PoGo Printer
www.polaroid.com

Sakura, Micron pens
www.sakuraofamerica.com

Sheer Heaven
www.cre8it.com

Zentangle, tiles, kits, workshops,
list of certified teachers
www.zentangle.com